THE WOMAN
WITHOUT A VOICE

PIONEERING IN DUGOUT, SOD HOUSE, AND HOMESTEAD

LOUISE FARMER SMITH

® Upper Hand Press

PO Box 91179

Bexley, Ohio 43209

USA

https://upperhandpress.com

Designed by David Provolo

ISBN 978-0-9984906-3-2

For Marilyn Storm Kestler,
Indispensible Family Archivist
and Beloved Cousin

STORM FAMILY TREE

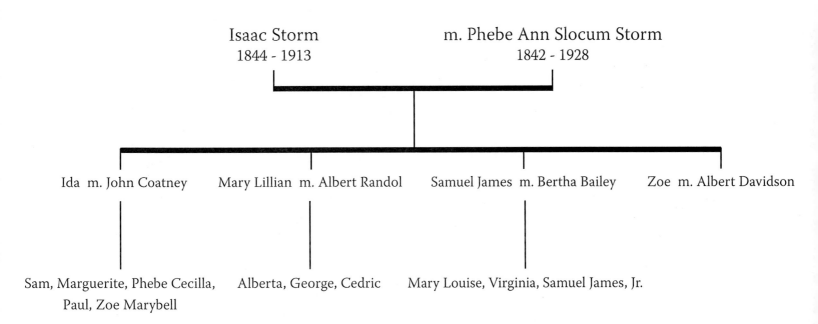

Isaac Storm
1844 - 1913

m. Phebe Ann Slocum Storm
1842 - 1928

Ida m. John Coatney

Mary Lillian m. Albert Randol

Samuel James m. Bertha Bailey

Zoe m. Albert Davidson

Sam, Marguerite, Phebe Cecilla,
Paul, Zoe Marybell

Alberta, George, Cedric

Mary Louise, Virginia, Samuel James, Jr.

THE WOMAN WITHOUT A VOICE

The pioneering men of the West, daring and stalwart, live very large in our estimation of ourselves and our country. Davy Crockett and John Wayne are our historic and fictional heroes. The importance of the frontier experience of these men is credited with establishing the very character of democracy.[1] But what about the pioneering women, their wives and daughters who cooked all their meals, faced the same blizzards, crossed the same treacherous rivers, and choked on the sands of the same baking deserts? With evidence from their diaries, this is the story of those women who worked like mules to get their families across the continent. And this is my story as I've tried to uncover the mysteries of the pioneer women in my own family—Ida, Mary Lillian, Zoe, and Phebe* Ann, the one they left behind.

*Phebe Ann Slocum Storm's parents used this spelling of her first name.

n late summer 1898 my great grandfather, Isaac Storm, faced a crushing combination of realities: Though he had spent years cultivating his fields and increasing his stock through breeding and purchases, he was almost out of cash and out of time. Deep in debt to the bank for farm loans, he watched his cash crop, corn, wither in a drought that had stretched on for five years. Should he try to get through another growing season, pray for rain and beg the bank for another extension?

In addition, there was another force as beyond his control as the drought. The economy of the entire country was five years into a protracted depression, the Panic of '93, which had severely depressed the value of farm commodities including corn. Isaac, his son and two sons-in-law had to decide what to do. As dust swept over their cornfields, those painful conversations at the kitchen table would have slowly shifted from what if they lose the farm to without money for a new farm, where could they go.

Isaac's farm had been prosperous before the drought and the Panic. We know this from a browned and tattered newspaper clipping. On January 18, 1893, before the dark hand of the Panic of '93 had cast its shadow on Nebraska farmland, the wedding of Isaac Storm's oldest daughter, Ida, to John Coatney was reported in the local newspaper. Someone clipped the article, perhaps Ida herself, wanting to save it to show to her mother, Phebe Ann Storm, who did not attend the ceremony. This clipping reports that the wedding was at home; a minister presided; and forty-five guests had dinner in the dining room. "Music and laughter" accompanied the feast. The groom wore a black suit and the bride wore a white silk gown. With her fair complexion and luxuriant dark hair Ida must have made a striking bride. In a later portrait she has that grim, determined stare that resulted from the photographer's charge of everyone to hold absolutely still for a full minute. But Ida, in spite of her pursed mouth is clearly a lovely woman, statuesque, as tall as her husband, John Coatney.

A white wedding dress was, at that time, a tradition only of the wealthy. White fabric was expensive and hard to clean; besides wedding dresses might be worn only once, and even if the dress could be passed down to sisters, the purchase of such yardage was a sign of a family doing well. Mary Lillian, twenty-one, the bride's sister and maid of honor probably

had a hand in making her older sister's wedding gown which in those days would have been more than enough work for her and the bride along with the youngest daughter, Zoe. That dress may have entailed the making of the voluminous leg o' mutton sleeves, popular at the time, and a great deal of tucking and detailed tailoring including covered buttons and bound buttonholes. The newspaper article also said the bride carried a bouquet of orange blossoms. These flowers must have been made of paper or silk since this was January in Nebraska, unless, of course, they had been whisked up from the south by train which is unlikely but entirely possible.

The newspaper article also included a list of the guests and the gifts they gave right down to the last pickle caster. Mary Lillian had pieced a quilt for Ida and John and bought them a silver cake basket. Isaac set up his oldest child with a linen tablecloth, a china fruit basket, a sewing machine, a cook stove and a cow, an abundant dowry given by a father full of pride and optimism. Zoe, the youngest daughter, aged twelve, must have been beside herself with excitement over her sister's wedding—gifts being delivered, menu plans and dress-making underway. The newspaper reported that Zoe

gave the couple a rocking chair. Perhaps Isaac helped his youngest with the expense of this piece of furniture, so essential to a farm home where many children were anticipated.

In the first month of 1893, Isaac Storm couldn't have guessed that financial troubles in Argentina and panic in Europe would drag his family under. Such news would have sounded remote and irrelevant to his family on their fertile farm in Nemaha County, Nebraska. But even then world trade sent menacing ripples around the globe. Argentina's agent bank had encouraged investment in the United States but that came to a halt when the US wheat crop failed and there was a coup in Buenos Aires. European investors were concerned about this sudden drop in investment and started a run on the gold in the U.S. Treasury. In February one month after Ida's handsome wedding, the Philadelphia and Reading Railroad went into receivership due to their overly ambitious expansion. This shocking news caused a run on the American banks as millions of people withdrew their money. Investors who held the paper on the railroads were wiped out. Financial panic in The United Kingdom and a drop in trade with Europe caused investors in America to sell their stocks and buy Trea-

3

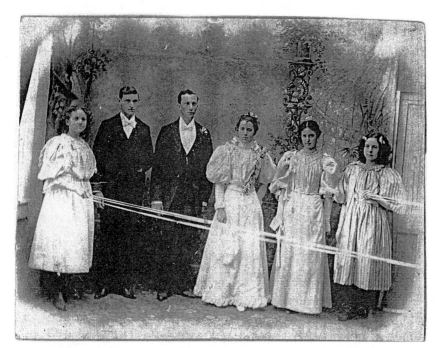

From left: Pearl Dray-Ribbon Bearer, Guy Hutchins-Best Man, Albert Randol-Groom, Mary Lillian Storm-Bride, Elizabeth Hyman-Maid of Honor & Zoe Storm-Ribbon Bearer. Randol and Storm Family Photograph

Isaac wasn't invested in the sinking stock market. Stocks and bonds were for fancy pants Easterners, and in 1896 the Storm family was able to afford another beautiful wedding.

Is this the white silk dress Ida wore? Very likely. Ida, the married sister, was pregnant and therefore couldn't be in the wedding party, so Mary Lillian chose a friend as maid of honor. The ribbon bearers were a tradition of the time signifying tying the knot. Guy Hutchens, the best man was a favorite cousin. As a very old man, Guy was invited to my own wedding.

The results of the Panic of '93 and its global domino effect began to shrink the prices Isaac could get for the corn he raised. The Storm family might have been able to hunker down and ride out this lengthy panic. They were already growing some of their own food and trading for much of the other materials they needed. But their cash crop, corn, was shrinking due to the drought which by the time of this second wedding had plagued the county for three years.

sury bills which could be exchanged for gold, thus sucking away more of America's treasure and prestige.

No newspaper report of Mary Lillian and Albert's wedding has survived, so we don't know anything about Isaac's gifts to his second daughter. There is evidence, however, that he gave over an interest in his farm to his new son-in-law, Albert Randol, perhaps as a wedding gift, but it is also possible he asked for some cash to pay bills and to help him make payments to the bank. But by 1898, two years after the wedding, the Storms had to make a decision. The bank was putting on pressure for payments at the same time their income was shrinking. What to do?

The Storms were educated people by the standards of the day. Phebe Ann Slocum Storm, Isaac's wife, had been a schoolteacher before she married. Mary Lillian and her younger brother, Samuel, had graduated from the state teacher's college in Peru, Nebraska. They, and especially Zoe, were avid readers, so they could have been lured south by what they read of the promise of free land. However, there had been a famous, chaotic Land Run into Oklahoma Territory in 1889, so thousands of prime acreage had already been claimed there, but the Nebraska newspapers advertised a way out for the Storm family.

Articles discussed the pressure to open not just Oklahoma Territory, land the government had already taken back from the Indians, but to open for settlement and cultivation all the land east to the Arkansas state line, the many square miles that had been promised to the Indians. As early as January 19, 1893, the *Omaha Daily Bee* reported that a conclave of community leaders from Missouri, Kansas, Nebraska, Iowa, Texas, Colorado and Oklahoma had convened in Guthrie, Oklahoma to push for the opening of the Indian lands (18,000,000 acres). Five thousand delegates attended.[2] Hard to believe this number but the railroads, desperate to open more land to settlement where they had already laid rails, were marketing the idea with fierce determination and lavish funds. Legislation drafted by these delegates not only called for the land to be open to white settlers, it called for the immediate destruction of all tribal governments and for the Indians to "adopt the ways of civilization." The argument that the Indians did not improve the land because they did not plant crops or build buildings was broadly believed though untrue of many tribes. If this proposed legislation passed the U.S. Congress, just a stroke of President Cleveland's pen would make this vast territory

available to white settlers, and the Indians would be limited to reservations. What an easy fix this must have seemed to that rowdy, probably drunken, crowd in Guthrie, legislating away the cultures of the Choctaw, Cherokee, Seminole, Muscogee (Creek) and Chickasaw—known as the Five Civilized Tribes.[3] This would make ancient traditions illegitimate, traditions the whites had no understanding of or regard for. Also losing their exclusive rights to the lands were the Kiowa, Arapaho, Cheyenne, Osage and the smaller tribes—Miami, Ottawa, Eastern Shawnee, Quapaw, Peoria, Wyandotte, Seneca, and Cayuga, who were already crowded into the northeastern corner of the future State of Oklahoma. This oblivious greed for land at the Guthrie Conclave would further betray treaties and trust, perpetuating miseries through generations of native people who had been promised peace and fertile lands in Oklahoma and Indian Territories. But as the depression deepened the clamor for free land grew.

It seems likely that the Storm family studied the "Description Pamphlets" available through the *Capitol City Courier*, a Lincoln, Nebraska newspaper. They were no fools, but plenty of rosy rumors came back from people who had visited there. The railroads gave interviews to all the Nebraska papers. They targeted ads about special rates for "excursions," round trips to view the glories of the territories. How else would the railroads justify all those rails they'd laid into unpopulated territory if they didn't encourage future passengers to stake claims far from their original homes where they would be dependent on the railroads to import their every need.

There were also earlier advertisements from the land speculators such as this ad in *The Omaha Bee* which prematurely took for granted that the Indians' land would shortly be open to settlement. The headline at the top of the page read, "The Gem of the Flowery Kingdom of Indian Territory, Oklahoma." The article began, "A Garden Spot" [with] "unsurpassed climate, grandly fertile soil, crystal spring water, health-giving mineral springs, extensive coal fields, etc." The article wound up with the unctuous vow, "I will not occupy your time by rehearsing these accepted facts."[4] See, the Storm men could say to their wives, this could be wonderful. This kind of advertisement lured settlers years before the land was legally open. Having settlers there in need of government protection enhanced the argument to open the land.

In case anyone is laughing regarding Oklahoma's being described as a garden spot, I want to defend our soil: Because Oklahoma has become in many minds synonymous with the Dust Bowl of the 1930's—a place made famous by John Steinbeck's *Grapes of Wrath*—it may be difficult to imagine my state as a breadbasket, but it was. Before the Land Run of 1889, the Five Civilized Tribes were already growing wheat in Indian Territory, a skill they had brought with them from their former homes in the American South.[5] The drought had been over in Oklahoma Territory two years earlier than in Nebraska.

What must have most interested the Storms as they read the news articles and developers' advertisements, was the description of the soil itself—thousands of square miles of fertile acres that had few trees to clear before they could plow and plant. What more could a farmer ask? The land was free to those who would stay on it. There were endless days of sunshine; people were said to be friendly; and hard work was going to guarantee success.

Talk of free land must have buoyed the spirits of the men in the Storm family for perhaps the first time in years. They were strong; they knew how to work hard. But what were the young wives in the family thinking? Among themselves and perhaps to their husbands, Ida and Mary Lillian must have voiced their fears about the loss of their community—their church, friends, and established schools for their children. These women were very social people, with ties lacing them to their neighbors and especially to their relatives. Their financially better off Uncle John Dement Storm and his family lived at a nearby farm, as did their mother's younger brother, Uncle James Slocum, a grain dealer and banker. One could borrow a cup of sugar or a horse or a cultivator from one's relative. Knowledge was pooled within families about farming, child rearing, diseases and remedies. To strike out and leave all these relatives was serious and risky. That network provided not only a social life, but a sense of security and mutual destiny. The same amount of rain fell or didn't fall on all of them.

Ida and Mary Lillian wanted to be good wives to John and Albert. That is clear from their reputations in the family and from the way they raised their daughters. Ida died before I was born, but I knew Mary Lillian and played at her spacious bungalow in Clinton, Oklahoma in the 1940's. Both women endured hardship in their marriages, but these were

obedient wives, and there would have been no shouting. In my family even tearful pleading against one's husband's will was unseemly for a woman whose husband depended on her to encourage his dreams and above all, to obey him. But Ida and John already had two little children and Mary Lillian and Albert had a baby girl. Giving up everything and taking to the road with little ones felt risky to these mothers and perhaps the fathers too. Wasn't it better to stay where they were, near their family doctor and the relatives they had grown up with?

Although thousands of women had already made the trek across the entire country beside their husbands in covered wagons in the 1840s and '50s, it wasn't until 1982 that we got a window into the thoughts of those women about leaving their homes for a wilderness. Lillian Schlissel, Director of American Studies at Brooklyn College, published over one hundred diaries written by pioneering women in the 19th Century, *Women's Diaries of the Westward Journey*. These diaries offered readers a way to capture the thoughts of women who were taught to hold their tongues. Whereas the men were talking of the great adventure of heading into the west to break the sod and fight the Indians, the diaries of the women speak of reluctance, not enthusiasm, for the great adventure. Alone, by the light of a candle or a kerosene lamp, they wrote privately of their anguish at leaving their relatives, and of the many practical problems of feeding, rearing and educating children without schools, a good doctor, law enforcement, and civilization itself. The newspapers fanned these fears by printing etchings of pretty white women being attacked by grizzly bears and savages. "O let us not go," wrote Mary A. Jones in her diary after her husband was "carried away" with the idea of making the trek to California. Abby Fulkerath perhaps knew she had no choice, "Agreeable to the wish of my husband," she wrote.[6]

Two people, husband and wife, sat side by side on the wagon bench. Though they looked down the same rough road and experienced the same dazzling or dismal scenery, the diaries suggest that they lived in different worlds. The women write that they had lost out in the debate about leaving their homes. "I left all my relatives in Ohio...& started on this long & perilous journey...it proved a hard task to leave them but still harder to leave my children buried in...graveyards."[7]

Agnes Stewart wrote of leaving her best friend. "O Martha, what I would give to see you now...I miss you more than I can

find words to express I do not wish to forget you, but your memory is painful to me I will see you again I will if I am ever able I will get back."[8] Yet each of these women had dutifully accompanied her husband as did thousands of other women.

"I'd give everything I own to be back home." This from a letter written by Isaac's sister-in-law after her husband moved the family from Indiana to Nebraska.

To argue with their husbands was seen even by the women themselves as disloyal and a betrayal of the wedding vow to obey. So the wife said goodbye to her friends, abandoned her aging parents and bid a last farewell to the nearby graves of loved ones. Few said, go without me. Nancy Kelsey, married at fifteen and caring for a baby is reported to have said before leaving, "I can better endure the hardships of the journey than the anxieties for an absent husband." So Nancy and her husband joined one of the most godforsaken wagon parties that ever set out. They trusted false maps and chased rumored short cuts. The men fought among themselves before splitting up and then rejoining. It was a member of this wagon party who stated that they were trying to "smell their way west."[9] Running out of supplies and traveling south when they believed they were traveling west, they had to slaughter the oxen that pulled their wagons in order to eat. They piled their most essential goods onto the backs of their mules. Later they had to slaughter their mules for food, and Nancy walked, carrying her year-old child.

"Women were expected to be strong enough to serve the common needs of the day, and strong enough to meet the uncommon demands as well. The society of pioneers yielded little comfort to frailty or timidity—or, for that matter, to motherhood." Martha Ann Morrison wrote in her diary about the grief of a woman whose daughter had died in childbirth: "I remember distinctly one girl in particular about my own age [thirteen years] that died and was buried on the road. Her mother had a great deal of trouble and suffering. It strikes me as I think of it now that mothers on the road had to undergo more trial and suffering than anybody else."[10]

Although at the beginning of the arduous treks to the west the women cared for the children and did all the cooking, they were soon called upon to pitch tents, help load and unload the wagon after river crossings, when wagons got stuck, or

9

when heavy rains drenched their goods. They helped yoke the oxen. (It took fourteen yoke of oxen to pull a heavy wagon out of the mud.) A wagon train would stop at a source of clean water, so that the oxen could rest, and the women could do the laundry.

This intriguing photograph is not my family. A photographer didn't catch up with the Storms until they had arrived at their new home. The names of these eight people have been lost, but there is a tough story here. Look at the face of the man: Turmoil, perhaps anger, and certainly hardship. Is he the only man left from these two wagons? Has he been overwhelmed with responsibilities? Look at the women, each one with her arms folded around her ribs. Perhaps they are uncertain facing a stranger, or nervous being photographed for the first time. Or perhaps the photographer has told them to grip themselves in this way to hold still for the full minute it took to record them on the photographic plate. For whatever reason, the mothers of these barefoot children stare out at us from in front of the only homes they had at that point in their lives.

The basics of life—food, water, and surviving accident and disease were everyday struggles for the pioneers, especially the mothers. Cooking was a challenge, daunting if it was raining or windy, and impossible if fuel could not be found, or if food supplies were low. To be serving only crackers and raw bacon didn't go down well with anyone, especially the woman herself. She dug holes to keep her fire out of the wind and sent her children to pull weeds and find buffalo dung for a fire. If it rained, she held a tarp or, if she had one, an umbrella over the fire to keep it dry, patiently facing the smoke and fumes while her family's dinner cooked. She made a constant effort to avoid a steady diet of beans by trading shirts and socks with the Indians for meat and fish. She picked wild berries along the way and rolled out piecrusts on the wagon seat.

Like Ida and Mary Lillian, the majority of 19th century women had been taught and deeply believed that the place of a good wife was one of submission to her husband. My own mother, born 1913, believed this although she was always on the lookout for loopholes. But historians agree that women of this period had little or no voice in the family's big decisions. "Papa has decided," a young girl wrote in her own diary.

Zoe Storm, eighteen and single, may have felt more adventurous than her older sisters about leaving their home. But having not yet found a husband, Zoe may have been even

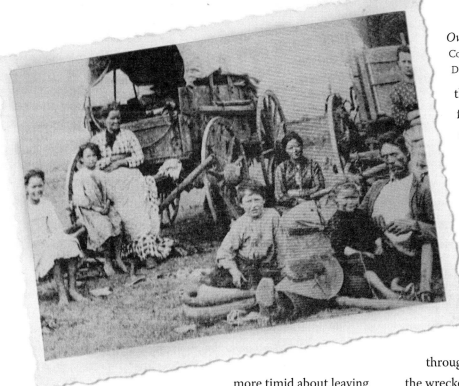

Overland Family and Wagons
Courtesy Western History Department
Denver Public Library

the women wrote nothing that has survived of their feelings. Mary Lillian left one note on the back of a photograph, but didn't sign her name. We'll read that later.

The whole country seemed in turmoil by 1898. Unemployment was at twelve percent. Thousands of angry, unemployed men, in an unprecedented march, burst into Nebraska on their way to Washington, DC to demand relief from the government. "In Julesburg, Colorado, these protestors had commandeered a locomotive and a string of boxcars. In their haste to get away [from federal marshals,] they ran the train through an open switch and off the track." The men fled the wrecked train and marched to Ogallala in western Nebraska where they commandeered another train and headed straight east. At that time the executives of the Union Pacific Railroad were powerful enough to take the law into their own hands. To bring these desperate men to justice the Union

more timid about leaving the community which would have eventually provided her one. Perhaps she already had a beau, one she was reluctant to leave behind. She left no diary of her thoughts. Nor did her sisters. Their father was facing ruin, but

THE WOMAN WITHOUT A VOICE

Pacific Railway Company "sent one hundred men on a train headed straight west from Omaha to bring this rowdy horde to trial. The ring leaders stood trial in Omaha, but the other prisoners were sealed in boxcars and taken west..." to be tried in the isolated Fort Sidney.[11]

This made hair-raising copy in the newspapers especially the *Omaha World-Herald*. No one in Nebraska could have missed this report of chaos, embitterment and lawlessness. Wouldn't it be better to flee out of range of chaos and newspapers to an empty, quiet place where there would be no mortgage on a man's land, where the sweat of his own brow would be his payment for home and farm.

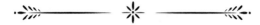

n the fall of 1898 George Isaac Storm and his son-in-law, William Albert Randol, tacked up flyers putting the majority of their livestock and equipment up for auction. The fields, house and sheds were not offered in the same auction perhaps due to the terms of an agreement with the bank. But if everything that could be sold was put up for sale, who in this depressed economic climate would pay enough for the farm to erase the debt? Here is the flyer the auctioneer printed. Odd that this tattered document should have survived in the family when so much else has been lost.

How many similar flyers were posted around Nemaha County regarding the possessions of other desperate families? How many people came to that auction? I mean, besides the neighbors who stood on the edge of the crowd to see how the Storms made out as they assessed their own chances of selling out. The more the Storms' goods brought at auction, the less their debt to the bank would be. I don't know what the total of the final bids was for their farm though, of course, it all went to the bank.

Regarding that Poland China thorough-bred boar mentioned on the flyer. A champion of the same breed sold in Omaha, Nebraska for thirty thousand dollars ten years after the Storm family rolled away from their farm, headed to Oklahoma territory.[12]

The scars of giving up that farm and the scars of failures that lay ahead barely faded with the years. When I was a little girl my aged grandfather, Samuel Storm, Isaac's son, said to me with an uncharacteristic grimness, "Banks will only loan

PUBLIC SALE.

On the farm of G. I. Storm, 3½ mi. S. W. of Peru and 8½ mi. N. E. of Auburn on Tuesday

OCTOBER 4 1898,

We will offer the following at Public Sale:

100 good shotes, about 25 head of sows, some have pigs and the others will have by the 1st of Oct., one thorough bred Poland China boar, 1 filly 2yrs. old past, 1 bay horse 7yrs. old, 5 fresh milk cows, 4 calves, 1 Buckeye Binder, 1 new departure cultivator, 1 wagon, 1 set nearly new hack harness, 1 set single harness, 1 disk harrow, 7 tons tame hay, 2 hay racks, and other numerous articles.

TERMS OF SALE.

Five dollars and under cash; 9 mo. time on sums over $5, purchaser to give a bankable note at 10 per cent; interest waived if paid when due; 5 per cent off for cash.

W. A. Randol, G. I. Storm.

Auction Flyer, 1898. Storm and Randol Family Keepsake

you money if you can prove you don't need it."

After the sale, the Storm family had only one wagon left in which to make the trip to Oklahoma. I noticed that in the public flyer there was no mention of a churn, wash tubs, or a sewing machine, the sort of things the women needed

and would have made sure were stacked on the wagon. Also the men would have needed plows and simple farm implements such as rakes, shovels and hoes as well as the few beasts in the remaining livestock. There would also have been boxes of canned fruits and vegetables the women had put up. In the end there was no room for the furniture. There was also no room for Ida, Mary Lillian, Zoe and the children to ride. Isaac decided that Albert would drive the wagon south accompanied by John driving the Coatney's wagon. What little cash they had would go for train tickets. Samuel promised that after they had a house, he would go back to retrieve the furniture which must have been left with relatives.

On the way to Oklahoma Territory the Storms' wagon would have been accompanied by the clucking of chickens in coops attached to the well-worn wagon which was trailed by a fraction of their mooing, oinking, barking animals—all of them moving only as fast as the pigs could walk. However much time this took, the men needed a long head

start to arrive, stake a claim, and prepare shelter for the rest of the family which spent a last Christmas on the Nebraska farm, according to Zoe's inscription in her new copy of *Farm Ballads*, a book of poems by Will Carleton. The mother of the family, Isaac's wife, Phebe Ann Slocum Storm, was alive, but she did not make the trip. I will explain this later.

The stories Albert and John told of their trek with the wagons and animals which took them from Peru in the southeast toe of Nebraska to western Oklahoma Territory have been lost as most family stories are. Told and retold, laughed about or bemoaned, they were never written down. How did they feed a moving farm? Which animals wandered off? Which man did the cooking? And how long did it take them in the winter of 1898-99 to travel over five hundred miles? We don't know the route they took, whether they followed streams and rivers in order to have water for the animals, journeyed parallel to railroad tracks, took advantage of the paths of cattle drives or moved from big town to big town all the way to Oklahoma City where they would have turned right to head due west to Weatherford.

And the women and children, pulled by that belching,

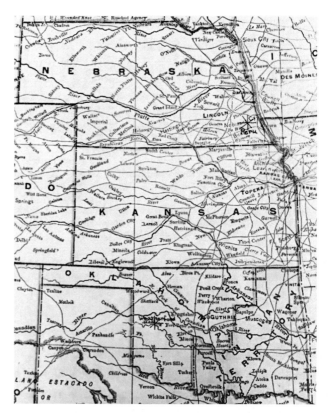

Detail from Rand, McNally and Company Indexed Atlas of the World Chicago, 1898. Courtesy of the Library of Congress Map Division

smoking 19th century locomotive? Their stories also, so alive and juicy at the time, have faded on the air and disappeared. The railroads' advertisements called the trips to view the glories of the Oklahoma Territories "excursions" as though they were day trips. But railroad maps of the times show a snarl of eleven competing companies offering short and sometimes non-connecting rail lines in Oklahoma and Indian Territories. If Isaac and his family had gone to the nearest train station in Nemaha County they could have caught the Burlington and Missouri River train to Beatrice, Nebraska. There they might have picked up the Chicago, Rock Island and Pacific train to Formosa, Kansas. From Formosa the most direct route in 1899 would have been on the famous Atchison, Topeka, and Santa Fe which would have taken them all the way to El Reno, Oklahoma Territory. Not too bad. But the Storms were not gliding swiftly into their new home on smooth iron rails. These trains stopped in every little settlement to pick up mail, load cattle, merchandise and produce. And each time the family changed trains, they were challenged to keep their children and their voluminous luggage with them. Excursion. Ha! This would have been a grueling trip, but of course, far easier than coming by wagon.

If only I had a surviving letter about that trip from just one of these great aunts of mine. Yet how grateful I am for those diaries of the women who survived the massive perils and suffering of the passages to California and Oregon. Although their stories lay silent for over a century their voices can now be heard in an era in which women across the globe are finding their voices. One hundred and twenty years ago, however, women lacked the rights men had. Many of the married women in the westbound covered wagons and the women of my family had not wanted to uproot their families. But women were not used to having their way in contradiction of their husbands. They were not protected under the law in regard to divorce, child custody, or property, and they couldn't vote to change any laws. A man or a single woman could stake a claim in the Territory, but a wife could not. A married woman's property, no matter how great or small, no matter its source, became the property of her husband when she married. The wife had promised to love, honor and obey, and although many of today's brides dispense lightly with the promise to obey, at the time of America's expansion into the frontier, the law of the land enforced that wedding vow.

15

Albert Randol holding his daughter. Alberta, and John Coatney Storm, Randol and Coatney Family Photograph

dependent on their husbands for protection, but there was little protection for women from their husbands.

More powerful even than the law was the ancient culture that judged women to be weaker, less intelligent, and morally more wobbly than men, as well as being a source of temptation to men, leading them into sin. The birth of the male child was, and to some extent still is, a cause for greater celebration than the birth of a little girl. Men believed this, and more importantly women believed it. She knew her place, and to abandon it with willfulness or anger was to sacrifice her chief gift, her femininity.

The men's journals of life on the trail record events: the breakdown of the wagon, the discovery of fresh water, a fight with an Indian party, or a case of cholera. Women's diaries record each person's death by name and date and note what became of the orphans—the names and ages of the children and the name of the family that took them in. It is the women who note the

Stranded within a claim of one hundred sixty acres, a woman's cry for help could not be heard by neighbors. Women were

graves along the way. Historians have called these women *the actuaries of the road* for their careful records.

It is hard for modern young women to believe that these wives didn't speak up about their fears and refuse the risk to their lives and the lives of their children in a wilderness. There were a few who did ask that their husband go ahead of them and at least establish a claim and build a shelter before the family joined him. In one recorded case the husband did let his wife and child stay home; he went west taking the maid along for company.

Of course there were even then women who spoke up loud and clear, ruling the roost, cowing their husbands and children. But a woman like this paid a price, ridicule from men toward her husband and herself and criticism from women who clung to the ideal of the lady-like female.

It is some solace to me that my family headed for the western section, Oklahoma Territory, and not into Indian Territory. Although both vast lands were the booty of grand larceny by the United States government, the planned opening of Indian Territory to the settlers was, at the time, the most recent broken promise to the native people who had already been dispossessed and forced to relocate

from the southeastern United States.

No matter what their reasons for choosing western Oklahoma, what my mother called "the short grass country," it was that choice that led to the dugout.

A month after the Storm family had reached their claim a photographer with a big camera and a tripod appeared. He wanted to take a picture of the pioneers in front of their new home, but he was told to wait while Albert descended into the dugout, (see the slanted door just behind him,) to rummage in his trunk for his swallowtail coat which you see him wearing here. Albert didn't want to look like a common sod-buster. He stands on the left, holding his little daughter Alberta. On the right is my great Uncle John Coatney, Ida's husband. He and Ida had staked their own claim. Alberta's mother, Mary Lillian, and her sisters Ida and Zoe must have been watching from behind the photographer, or, interrupted in their work and with only five hairpins between them, they didn't want to be photographed. Ida was also visibly pregnant. The head of the family, Isaac Storm is also missing from the picture.

Albert Randol was the one to present himself proudly for the photographer. Besides Albert and John, the names of

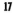

the horses have survived. Although Mary Lillian did not include her own name, she dutifully wrote on the back of the dugout photograph that the horses were named Daisy, Pet, Prince and Chub and the dog sitting beside John was named Fritzie. She also wrote:

1898, [perhaps 1899] one month after arrival in Weatherford, Oklahoma Territory, from Peru, Nebraska where we had raised corn until the Panic of '93, (Drought, no crops) Grandfather Storm had only $800.00, so we packed up the wagon and left the walnut and marble-topped furniture. On arrival in Oklahoma we had meat from poultry and hunting, canned fruit, 2 doz. Hens, 4 pigs, 3 horses, 1 pony and 1 cow. We owed $450.00 and had 30 cents to live on until making crop. Added later: *Our hay was destroyed by fire.*

This sounds dire, and I'm sure there were many times when these people had little to sustain them but their senses

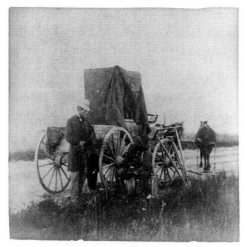

A rare find
Courtesy of the Library of Congress
Prints and Photographs Division

of humor. Mary Lillian who had a teacher's college degree was in charge of gathering fuel. When I was a child, she said to the family with a twinkle in her eye that there was not a pile of dried buffalo dung for miles around their claim because she had gathered it all. She didn't mention this in her brief note on the back of the photo. She was probably being delicate.

This photograph has been displayed in Oklahoma historical museums and pops up in journals. But most important, it has come down in the Storm, Randol and Coatney families, a record that proves, however lowly the circumstances, our family was there on a frontier, coping with the fundamentals of livelihood.

Photography on the prairie? How could a family be given a finished photograph in the middle of a vast plain? Where was the darkroom? Above is a photograph of a photographer. Each photographer's set up was his own contrivance, but each

one carried with him his darkroom on wheels.

So what were the first thoughts of Ida, Mary Lillian, and Zoe when the wagon that had brought them over forty miles from the railhead at El Reno pulled onto this treeless claim? Search that horizon behind Albert and John. This was the land the pioneers didn't have to clear: No trees to cut down or stumps to dig up. Just start plowing and get that crop in the ground! But there were also no trees for building a cabin or a fire for warmth or cooking or washing. No trees to cut for a stick of furniture. No trees to break the wind or offer shade from the relentless Oklahoma sun. There was nothing much for the women to see except the dugout, the only answer to the immediate need for shelter.

I don't know how long they lived there, but it looks like a windowless hole in the ground to me. Look at it. That door, possibly made from side-walls ripped from the wagon, leads into darkness. Did the women bring the candles and the Kerosene lamps on the train or were those on the wagon? There was a stove of some sort suggested by the pipe-like chimney at the back.

The family had already lived in this hovel a month when that photographer showed up. It must have been very crowded with five adults and a little girl. (The Coatneys were on a separate claim.) Though pioneers were seeking many acres of land, they were willing to put up with tight quarters while they "proved up," meaning complied with the terms for homesteaders. People slept on pallets that they folded up during the day. Besides, most of the work to be done was outside—getting the crops in, running fences, and building sheds for the animals. The stove inside may have been for heat only, as cooking would have been much easier outdoors in the daylight.

Some of the Storms may have bedded down in the wagon or under the stars, but if it were raining, or a high wind had come up, or a tornado was sighted, they all huddled in the dugout, probably with the chickens—those fluffy things being so vulnerable to high winds.

There are fond memories of dugouts at least looking back after many years as recorded by this WPA interviewee:

"As building materials was scarce and hard to get, it was necessary for many people to live in dugouts. Ours was builded [sic] into a side of a hill. With the

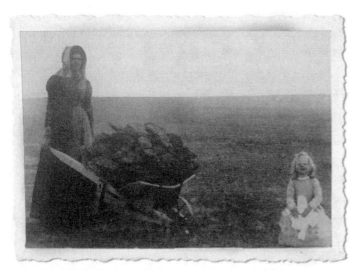

Ada and Burt McColl. With permission from Western History Collection University of Oklahoma

front made of lumber. It was a large room 16' x 18', perfectly comfortable and absolutely secure from the wind storm which was so prevalent in that section of the country. We had plenty of light as we had nice glass windows on the front. That was the home in which I was born and in which my parents lived with their nine children."[13]

This is Ada McColl, photographed with her baby brother, Burt. Ada is pushing a handsome wheelbarrow full of *bois de vache*, the French words for wood of the cow, also known as meadow muffins. When the pioneers moved across open plains where there were no trees with which to make a fire, buffalo dung was the preferred fuel. It took three bushels to make a good hot, clean flame that was virtually odorless. In the evenings pioneers on the trail carried the smoldering remains of the dung fire into their wagons to drive out mosquitoes.[14]

Miss McColl has on a sunbonnet to protect her complexion and appears to be wearing a corset. Though she is pushing a load of manure, she maintains a lady-like appearance. Encumbered by skirts, the pioneer women often did men's work, but they held fiercely to their femininity, and "to the ideology centered on the supposed natural characteristics of women: purity, piety, submissiveness and domesticity." In general the pioneer women remained hopeful of a future where that femininity might be more realized and protected than it was on the road.[15]

A word is necessary about Ada's brother Burt, his pretty dress, flowing locks, and doll. As you will see in a later picture of one of the Randols' sons, little boys of this era were dressed as little girls.

Not all dugouts were as simple as the Storms' which they must have assumed was temporary. But all dugouts by definition had invaded the territory of creatures that lived in the earth. Snakes fell out of the ceiling to land in the laps and on the plates of folks sitting down to supper. Wasps, yellow jackets, and scorpions tormented dugout families. Women hung muslin sheets along the ceiling to catch this fallout. They pasted newspapers on the walls to hold in the dust. One woman reported watching a scorpion slithering under the newspaper on her wall. She stabbed it with her scissors.

This free land came with certain requirements. A man or single woman could gain the rights to one hundred sixty acres if they stayed on it for five years and improved the land. Included in these improvements could be fencing, putting in crops and building sheds for animals, but there also had to be a home for the family. At the end of the five years an inspector would come to their claim to see if they had fulfilled the requirements before giving them a deed to the land. Many people had brought tents to live in on their trip, but tents did not qualify as improvements for the land. The home could be a dugout or a sod house, but the inspector's requirement was that the house must have a glass window. That was a problem.

Glass was expensive and hard to come by. Many families, like my own, had showed up broke. It is reported, not of my family, of course, but it is reported that on the final day, after the inspector had signed off on one man's fine home and its lovely window, a neighbor with a fast horse would show up and borrow the window to stick in the hole in his own front wall. Furthermore, it was reported by historians that whole little frame houses made of lumber from Texas were moved with ropes and horses from claim to claim to outrun the inspectors. There were even houses built on skids to make the hauling easier.

If a family was considering a dugout as a permanent home there were many ways to improve upon the simple dugout. In the photo on page 22 a family has dug into the side of a hill and put up a wall of sod blocks in the front to hold their window.

Note the table that looks to be holding pumpkins or watermelons, signs of this family's hard work and the fertility of their land. Another wall made of sod creates an open room for animals. This established home shows the strength of the sod as building blocks. The large tree trunk is supported by the sod

walls in spite of the shifting weight of an attached swing. Even more amazing is that a wagon and team of horses has driven up onto the roof with a load of sod, probably for repair of the roof. This is the remarkable stability of the dugout which uses the terrain as it is and burrows into it, thus making the family invulnerable even to tornadoes which flowed over the hill. These houses were cool in the summer and warm in the winter. Note the smokestack in the photograph.

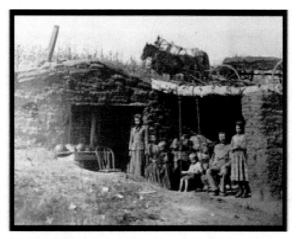

Dugout with Wagon on Top
With permission from the Solomon T. Butcher Collection, Nebraska Historical Society

In the above photograph is a young woman in a suit. She is most likely a schoolteacher who is boarding with this family of five. Like the Storms, this family put up with crowded conditions while they were on their way to the homes of their dreams. It was not uncommon for a family with four or five children to take into their two-room sod house several boarders.

The Storms stepped up from their dugout to build themselves a sod house, and Mary Lillian is reported to have claimed that the day the family got out of the dugout was the happiest day of her life. But sod houses were not easy to build. Having roofs that carried enormous weight, sod houses were feats of engineering, but if they were well built, they could be very snug. Building blocks of sod were cut with a curved plow blade and a team of horses or oxen. Cutting this virgin soil caused an alarmingly loud noise as the massive root system was snapped off. A "ribbon" eighteen inches wide would be cut through the sod and then divided into two-foot sections, four to six inches deep, to make an almost perfect building block with good insulating properties. The foreground in the Storm's dugout photograph shows evidence that they had begun to cut these blocks. The settlers called it Nebraska Marble.

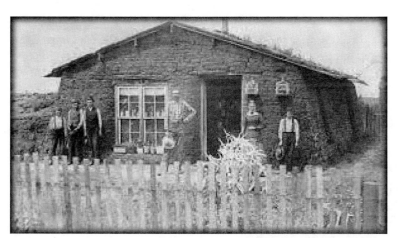
Sod House. Courtesy of Library of Congress Prints and Photographs Collection

Dugout Schoolhouse. Kansas Memory-Kansas Historical Society

There is not a photograph of the Storm's sod house, but here is an exceptionally beautiful example of one built during the same period.

The sod blocks were laid with the root side up so that with a little rain the roots could grow into the block above making a tight fit. Only the blocks of sod which were going to be laid that day should be cut because they dried out quickly and would be too hard to handle. It took three thousand blocks of sod to make a small house, thus the combination of dugout with a sod front wall was popular for farmers pressed by the seasons to get their crops in the ground.

In this photograph the sod house's foundation is wider than the rest of the walls, thus the appearance of melting. But it was this intentionally wider foundation that assured much greater stability. The greatest problem with a sod house was the roof, both tricky to build and dangerous. Roofs could

be reinforced with cedar poles if they could be found. Grass tied in bundles was used for insulation before sod was laid across. Cave-ins of the roofs were common. This was another advantage dugouts had over sod houses although it is said that tornadoes left the little soddies undisturbed as well.

On page 23 is a beautiful example of a dugout schoolhouse. Four, count them, four beautiful windows. Note the outhouse at a decent remove on the left. I spoke with an Oklahoman whose grandfather had graduated from a dugout school. Of three fellow students his age, each went on to receive a PhD. Two of them taught in universities.

Isaac was not only generous, but wise to buy those tickets to bring the family into Oklahoma Territory by train. Travel in wagons was especially perilous for children. If a child fell off a rolling wagon, it was usually run over. Whether Isaac was aware of it or not at the time of the trip, birth records show that Ida was pregnant with her third child whom

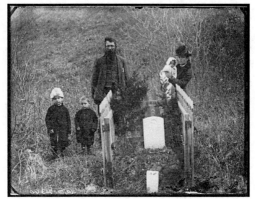

The Harve Andrews Family Visiting the Grave of Nineteen-Month-Old Willie
With Permission From the Nebraska Historical Society

she would name after her mother, Phebe.

Not all men were as considerate as Isaac. Children and childbirth during this period were considered entirely women's responsibility and yet custom prevented women from even telling each other that they were pregnant. I have a stack of over ninety copies of letters given to me by the Sod House Museum in Aline, Oklahoma. All of these were written in 1897 by a young wife, Bertha Newby Hutchins, back to her family in Kansas from the sod house where she and her husband were living in the Jet area of Oklahoma Territory. It is clear that she did not tell even her own mother she was expecting. Pioneer women delivered babies in dugouts, sod houses and rolling wagons with the help of other women if there were neighbors or with only the help of their husbands if they were alone. If a woman died in childbirth, the record showed only that "she suddenly sickened and died." The idea of sex was so forbidden that it was

against the rules of decency to mention pregnancy.

Willie might have been the first-born child or the one in between the infant and the smallest of the two little boys. It appears that the Andrews live in a settlement. She is wearing a Sunday hat as opposed to a bonnet. The family is dressed for winter. The gravestone, perhaps cut of limestone, suggests a permanent cemetery. The grave could be fresh. Before they go back home, they will nail back the fourth wall of the fence, built to keep out wolves.

Mr. and Mrs. Andrew's faces are stoic as are the faces in most 19th century photographs, but the presence of the two tiny boys and the infant in her arms testify to Mrs. Andrew's heavy responsibilities as mother and healer. Does she blame herself for not being able to bring their Willie, back to health? One of the roles of the pioneer woman was to care for the sick. She was also the compounding pharmacist. If her child had a mouth sore, she mixed sage, borax, alum and sugar if she had these ingredients. She might have on hand a box of physicking pills, a quart of castor oil, a quart of rum, a large vial of peppermint essence and camphor. A well-supplied home would also have quinine for malaria, hartshorn for snakebites, citric acid for scurvy, "and opium and whiskey for everything else."[16] Unless she had the help of a doctor, the mother had to diagnose her family's symptoms, prescribe, administer the remedy, and pray for the best.

If the family was in transit at the time a child died, there was nothing to do but bury the little body beside the trail. To leave a child's body in a grave beside the road wrenched the hearts of parents who were torn between marking a grave so that it might be returned to and hiding it, so Indians in search of clothing could not find it and wolves could not dig it up.

Of course, adults also were killed by disease and accidents. Among diseases, cholera took the greatest toll among the mid-century pioneers, striking down its victims within twelve hours from first symptom to agonized death. In her diary Ester Hanna wrote: "O tis a hard thing to die far from friends & home, to be hurried into a hastily dug grave without shroud or coffin, the clods filled in and then deserted, perhaps to be food for wolves."[17]

One solution to the vulnerability of graves was employed by pioneers on the Oregon Trail. They dug the grave in the road so that the herds, oxen and wagon wheels would

tamp down the earth of the fresh grave thereby sealing off the body's scent from wolves.

<div align="center">———— ✳ ————</div>

Here is the Storm family, in front of their nice frame house in Clinton, Oklahoma. Note the huge window. I don't know the date for sure, but the well-stockinged lass with the expensive doll is Alberta, the girl who was a babe in her father's arms in front of the dugout. So this was taken around 1908. Alberta's two younger brothers are George (barefoot) and Cedric astride his wooden horse. (Don't let the dress fool you, Cedric was a real rascal who later put himself through law school playing cards.)

Isaac is seated in the rocking chair. Mary Lillian is second from the right. She was a very sweet and generous woman, her grimace notwithstanding. Albert, the man on the far left, his face showing the pale forehead of "a farmer's tan," is Mary Lillian's husband, Albert. Zoe, the youngest of Isaac's children, has married since coming to the Territory. She is the woman on the far right and her husband "Davy" Davidson is third man from the left. Davy worked for the lumberyard as a teamster which meant he drove a wagon and team and may have brought in lumber from Vernon, Texas. With her earnings from her post office job, Zoe bought Davy a farm. Perhaps this was so he could talk to the other men about farming and worry about the weather. However, my mother told me Davy didn't take the advice he was given about what to plant and when, so he never successfully raised a crop. I think if it had been Zoe's own farm, she would have listened to the advice of the most successful farmers and made a go of it. But she would never, ever have said this to Davy.

One of the most troubling traditions among the women in my family is reflexively protecting the men. Protecting them from what? a friend asked. Protecting them from knowing what disappointments they are, I answered although, of course, this doesn't apply to all cases in my family. In *One Hundred Years of Marriage*, my first book, I touched on this subject. That book is a completely fictionalized version of my family story, but as I go back and read it, I see how close to the bone I cut in the last section at the church where the maid-of-honor, her patience wearing thin with the bride, cries out, "It's like

Isaac Storm's Family on the Porch in Clinton, Oklahoma—Storm Family Photograph

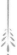

some sort of marital DNA your kind passes down the generations…You think marriage is about women being kind to men."

"You think that's why I'm marrying Josh?" the bride asks.

"You can't beat this game. It's what you're trained for. Look at your mother."

Here is Zoe in her own new wedding dress. She looks a little tentative. Perhaps she was simply uncomfortable about being the center of attention. Note the fashionable demi-train.

That leaves my grandfather, Samuel Storm, already a widower having lost his beloved Maggie to "shock of surgery" one month after their wedding in 1904. In the picture on the porch he wears a vest and a

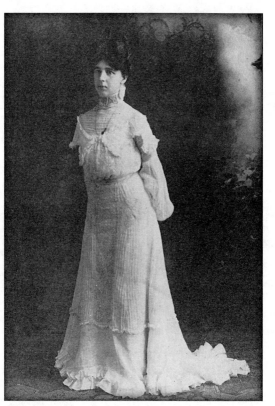

Zoe Storm Davidson in her Wedding Dress.
Storm Family Photograph

white bow tie and stands between Albert and Davy. He, the scholar in the family, published the local telephone directory where he included the professions of each man, one being identified as "poet." Samuel's own ad in the directory recommended him as a Public Stenographer. I wonder if he hammered away on the same huge black typewriter he used at my parents' house forty years later when he worked on his memoirs.

How did the Storms rise from broke settlers in a dugout on a treeless claim to Clinton, Oklahoma town folk? Isaac, the father of the family, had been recognized early as a man of character and one who could be trusted with responsibility. When he was very young he had been General George Custer's orderly during the

Civil War and rose quickly through the ranks from recruit to Sergeant. But he was also tested with great sorrows. As sixteen-year-olds claiming to be nineteen, he and his twin brother as well as his older brother enlisted with the Union Army. The Union troops had established a recruitment center at Bowling Green, Kentucky. There in the crowded barracks 800 young recruits died of typhoid, Isaac's twin brother, Joseph, was among them. Isaac's older brother, Samuel, was wounded in battle and reported killed, but it was discovered that the boy had been captured. He escaped and returned to service only to be captured again and held in the infamous Confederate prison in Andersonville where he died at the age of twenty-one or twenty-two of scurvy and starvation.

Now in late middle age, Isaac was elected Justice of the Peace in Clinton where the family moved and built this house in 1903. Isaac and his son-in-law, Albert Randol, went into the real estate business, buying and selling farms. "We Sell the Earth," their ad in the phone directory said. Making a farm out of raw prairie was not for everyone. Many men who staked claims were eager to sell out once they had "proved up." Since they had paid nothing for the land, they could let their farms go cheaply and still have some cash to start over elsewhere or to stop farming and go into business. The Storm-Randol real estate business could buy these farms and sell them at a profit to men who had missed the earlier land runs.

Albert was the go-getter in the family, a successful wheat farmer with the energy to run a business on the side, especially with Isaac, a well-known man with a spotless reputation according to newspaper records and family reports. "Broad-minded and warm-hearted," men wrote about Isaac Storm whose life experience and early losses may have settled on him a sense of gravity.

It was not only the men who made money. Zoe, Isaac's youngest, ran the post office in Clinton, a job she managed single-handedly for thirty one years. She was not the postmaster, of course, that was a man's job. Ida, the oldest daughter, and her husband, John Coatney, lived and farmed near the neighboring town of Weatherford where the Storms had first settled.

The lumber for that Clinton house in the picture was probably delivered from Texas to a railhead and picked up by wagon although wood also came into Oklahoma from the Pacific Northwest—Oregon and Washington State. The rail-

roads' bet in luring people to the territories had paid off big. Everything the pioneers needed, from plumb bobs and plows to baby chicks and china had to be brought in by rail.

Life was good in western Oklahoma. The soil had yielded and yielded until it didn't. "Clinging to the mystical belief that *rain follows the plow*, Oklahoma farmers had over-cultivated and over-grazed much of their land."[18] The causes of the Dust Bowl make for controversy among scholars and ordinary citizens, but one cause was the shallowness of the topsoil. My friend, Boots, once said to me, "Oklahoma soil should never have known the blade of a plow." Easy for Boots to say; his family was in oil.

When, as a child, I first saw this photograph of my great grandfather's family on the porch in Clinton, I assumed that Great Grandmother Phebe, Isaac's wife, was holding the camera. From everything I had been told about this sweet, generous woman, I regarded her as the family saint—a Quaker of quiet dignity, self-effacing, more than willing to forgo being photographed. My mother had told me about how kind she was, always one to take up for the underdog. She made pretty dresses and meticulously kept her bedroom in the Randol home. "Everything she had was pretty," Mother said. An ornate black silk dress of hers survived into the 1950's. I was allowed to try it on. It fit perfectly when I was thirteen. Where is that dress? My mother probably wrapped it back up in tissue paper. It was in a fragile condition. Phebe herself was also in fragile condition in 1899 when the rest of her family got on the train headed for Oklahoma Territory.

After I was an adult, my mother told me the truth about why the woman we called Grandmother Phebe was not in the photograph of the family on the porch. Isaac Storm had taken his wife to the Nebraska State Asylum in Lincoln shortly before the family took off.

I pondered this for decades in the way we hold in our minds mutually excluding visions. Was she this quiet and kind grandmother, or was she some out-of-control crazy person who had to be locked up. My own opinion was dominated by the benign picture my mother had painted of her grand-

30

mother, one who always had a dime to give her little grand-daughter. This was reinforced by the evidence of the elegant black silk dress and a pretty little chain-mesh handbag. These were usually enough to snuff out the one sentence Mother said about an asylum.

So Grandmother Phebe was back up on her sainthood pedestal by the time I, a middle-aged writer, ever thought of writing about her. I wanted to include her generation in my first book, *One Hundred Years of Marriage*. Though that book was all fiction, I knew that the best fiction must create a reality that grows out of the mind of an author who has her facts straight. So I hired a Nebraska lawyer and got a court order to retrieve my great grandmother's records from the asylum in Lincoln.

The mystery of Phebe Ann Slocum Storm had ridden along in the bosom of my family without resolution. My generation doesn't whisper about her. We speak openly, although I'm sure Samuel's first ill-fated bride must have wondered where the mother of the groom was. The crush of losing his bride one month after the wedding was devastating. After that Samuel did not fall in love again for nearly six years.

It was Samuel's younger sister, Zoe, who introduced her brother to Bertha Bailey, my grandmother. She too must have felt the truth about Phebe Ann Slocum Storm was too much to say out loud. When she and Samuel married in 1910, Samuel's mother was still in the asylum. How did Samuel explain all this to his bride? Did he even tell her?

Being the chosen partner of the only son, Bertha Bailey, Samuel's second fiancée, was the only female outsider in the family. Ida, Mary Lillian, and Zoe knew all about their mother and may have urged Samuel to put off telling the lovely Bertha this particular bit of the family history. On the other hand, Bertha was so close to Zoe, the two friends may have already talked over Zoe's mother's fate. We don't know.

Bertha was stiffly proper in regard to decorum and the rules of civility. On the other hand she was a hard-working woman who had lost her own mother when she was in her teens. Her father had married a wealthy widow in heart-breaking haste.

Bertha was a milliner who modeled her creations at church on a glorious pile of red hair. The ladies in the congregation couldn't miss her fresh creation, and at least one

would ask to buy it. She was also a water colorist and a china painter, as well as a copyist in oil of famous religious paintings she gave to her church. She'd had only one year of training in art because her father didn't believe in education for women. He also didn't believe in the education for cripples which included his own son, Pell. He insisted that Bertha leave off dabbling in paint to care for her brother and himself. He didn't want her to marry, and she had held off suitors until she was thirty-three, long on the vine in this era. Her father would not be denied the care he thought he deserved, so he and his cat, the only creature to whom he showed any affection, moved in with Samuel and Bertha after they married.

Bertha, called Bert by her friends, had style. With an eye on fashion magazines, she was well-turned out, having created every part of her apparel except for the hosiery and shoes. Besides this, Bertha was sweet in all the ways a woman of this era was supposed to be: self-effacing, kind, gentle and deferential to her man.

However it was that Bertha learned about Samuel's mother, the news must have been a shock. Bertha was well aware of Phebe's absence from their lives. During this period it was the practice of families to keep their mentally ill members at home, perhaps locked in the attic, a secret not to be mentioned outside the house. Bertha's first thought must have been that if a person was so bad off as to be put away in an institution, she must have been stark-raving mad, perhaps a danger to others. The causes of insanity at the time were considered fifty percent heredity. What might this mean for their future children?

Samuel must have sensed in Bertha the kind of woman who, like his mother, would never criticize her husband. And Bertha was undoubtedly attracted to an educated, well-read, well-spoken man who valued

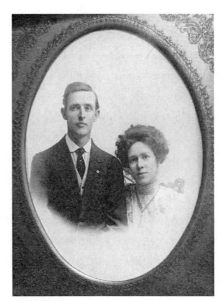

Wedding Photograph Samuel and Bertha Elizabeth Bailey Storm
Storm Family Photograph

her artistic side and built frames for her paintings and after marriage read to her while she made hats and painted china for other women. In spite of Bertha's age, they had three, well-spaced children. Unfortunately, Samuel never made a steady living. He would take small part-time jobs and had one good job buying horses for the government during WWI, but even during the Depression in the 1930's, he refused to seek work. Bertha paid the bills and deflected any critic who confronted Samuel, even her own daughter, my mother, Virginia. She was trying to finish college while holding down a full-time job. She allowed herself one flash of anger at her father—"There is no food in this house!" She said this after her father refused to follow up on a teaching job she had found for him. Bertha got up out of her sick bed to confront her daughter, "How can you speak like that to this sweet man?"

Bertha designed a simple gold and white china pattern especially for the family doctor. She bartered many place settings and serving pieces with Dr. Lamb for his services delivering the three Storm children, removing their tonsils and appendices, and caring for her own failing heart. Bertha's industry at teaching watercolor, china painting, and millinery,

linked with Samuel's preference for quiet reading at home, ensured the family a life of financial hardship.

In the 1950's after Bertha's death, Samuel began to write while he lived with us in Norman, Oklahoma. He pounded out reams of memoir on his old Remington in the back bedroom he shared with my little brother. He also wrote children's stories. "Mr. Hurricane" was the story he said was mine. This story was a mixture of science and charm meant to educate the young reader as to how hurricanes developed in tropical waters and how they traveled and eventually dissipated. His memoir, *I Said to Mama*, was, on the other hand, a way of reliving the stories of his youth and continuing his life-long conversation with Bertha. Whatever Samuel had told her about his mother, Phebe arrived in Clinton three years after their wedding.

Phebe Ann's record from the hospital says she *"first showed mental after confinement,"* meaning childbirth, after the date of Samuel's birth. She was not brought to the asylum that time. She was first committed nine years later after the death of an infant, Sally Edith, who died at the age of two months, in the winter of 1885. Could this have been a severe

post-partum depression? The record said a sister of Phebe's might have suffered similar problems.

The record of her February, 1893 admission was long on objective detail. Phebe Ann Slocum Storm was *50 years old, 5' 1 ½", 107 lbs., Pulse 72. Temperature 98.5* Her education was described as *"Good—teacher before marriage."* She had *four children, ages 11-21.* Her presenting symptom: *"Nervous. Thinks someone is going to kill her and her family."* Her habits and self-control were described as: *"Cleanly–Temperate."* Under the word *Violent* the record said *No. Homicidal?—No. Suicidal?—Talks of it.* Diagnosis: *chronic mania.*

I hated to think about the stark contrast between the gentle Phebe of family lore and this anxious, woman, talking of suicide. Her age, 50, at the time Isaac brought her back to the hospital suggests that she had entered menopause, another hormonally difficult time in a woman's life. The concept of hormones and the role they play in each woman's fertility was not developed until 1905 by an Englishman, Ernest Starling. Too late for Phebe.

There is a link between hormonal changes and post-partum depression. But the severe cases of postpartum depression usually occur in women who have a pre-existing, underlying depression. Whatever coping methods these women used to deal with their depression were overwhelmed by the hormonal storms they suffered after childbirth and at menopause. So for Phebe, it probably wasn't garden-variety post-partum depression, but something more severe, an underlying melancholy and anxiety from which at that time there was no pharmaceutical relief.

The hospital record shows that she was "Paroled June 20, 1896." But two and a half years later as the farm was failing, the price of corn falling, and the family beginning to face foreclosure on their loans at the bank, Phebe Ann was returned to the Lincoln Asylum.

I could no longer ignore the fact that Grandmother Phebe had been in real trouble whether she was insane or not. And why would a good man like Isaac, a man revered by his community and reported to be kind and patient with children, abandon the mother of his own children and leave her in the hands of the state?

In *One Hundred Years of Marriage*, a novel in stories, I wrote an imagined version of what might have happened if

Phebe had made the trip to the claim in Oklahoma Territory, and faced descending into a dugout. That part of the novel, "Return to Lincoln" is a grim story narrated by the eleven-year-old son, Dan. At the time, I was trying to portray a trauma my grandfather Samuel, Phebe's son, might have suffered when he was a boy that destroyed his confidence, making him unwilling to try to get work even when his family desperately needed money. In that book Dan describes forsaking the new claim in Oklahoma Territory to take his mother back to the asylum in Lincoln.

The photocopies I received from the former Lincoln Asylum were made from a big journal and expressed in sentence fragments. They form a sketchy view of my great grandmother on some of her worst days. There was frustratingly little detail about how Phebe Ann lived and no mention of any treatment. Given the concept of mental illness accepted then, I wanted to believe she received no treatment.

First let me say that during this period there was far-reaching reform of mental hospital practices in the United States. Even though the language of prisons (patients were paroled) remained, the treatment of patients had improved over the squalid madhouses of the 18th and early 19th centuries.

Invoices showed that rubber restraints replaced iron cuffs, and patients could leave their rooms to walk on the lawn. Pen, paper, and postage were provided so that patients could write to their friends and family. They could bring their own furniture and curtains. Insane people were no longer punished for being insane. The concept of *moral therapy* was much talked about by the doctors and medical journals. The idea was that patients were not responsible for their erratic behavior and should be treated with kindness. This allowed for as much freedom for the patients as the staff felt they could handle.

But the fact that there were no psychotropic drugs to ease depression or psychosis meant that the doctors had to rely on trying to keep the patients from harming themselves or others by the use of straitjackets and sedation using potassium bromide and whiskey. Under the standards of Moral Therapy, the doctors also prescribed hydrotherapy (baths,) electrical stimulation, rest, exercise, farm labor, wrapping in wet sheets, good food and much attention to the bowels and stomach. Their drug supplies included leeches, morphine, opium, rhubarb, tincture of gentian, wine, cooked beef blood, and small doses of arsenic and strychnine.[19]

Besides heredity the causes of mental illness were believed in this hospital to be overwork and "want of proper food and regular bathing, as well as domestic trouble, disappointment in love, financial trouble, hepatic dullness, masturbation, intemperance, overwork, over study, religious excitement, sun stroke, satyriasis and other suspected origins."[20] Various theories had doctors and administrators in the Lincoln Asylum treating mental illness like constipation—purgatives and hot enemas prescribed to drive out the demons.

There are two themes in Phebe Storm's records. She had periods of being *"troublesome"* and periods of being *"no trouble at all."* The following describes a bad day. She was *"Very noisy at times—scolds about being kept in her room at night, wants to go home." "Very much excited. Preaches and argues constantly in a very loud voice."* Her loudest complaint was that she was not allowed to write letters. Over the next month, she grew quieter and continued to be physically very well.... *"Has fewer disturbed spells."* The other and overwhelming theme in her records was repeated over and over that she was *"pleasant," "lady-like,"* and *"temperate."* And *"helpful on the ward."* I was glad to learn that she was permitted to help

and did so. The records said, *the family had asked that she not be required to work,* and I'm guessing that this related to the Asylum's being a self-sustaining operation with a farm that produced all the food and dairy for the staff and patients. Patients were required to supply all the labor for the farm. Evidently Isaac asked that his small wife not be required to work in the fields, though helping on the ward, perhaps carrying trays and comforting other patients, would have been fine with the family. All the members of our family value having productive work to do.

One of the reasons my family treasured Grandmother Phebe was her link to another Quaker, our most famous and revered ancestor, Mary Dyer (c.1591-1660). Mary Dyer made her mark on history by standing firm in her belief that it was possible to be faithful to God without following the laws of Puritans' theocracy. Mary and her husband, William, fled Massachusetts after the Puritans outlawed Quakers and enacted the savage Cart and Tail form of punishment, tying a Quaker to a cart and flogging him as the cart rolled from town to town until it was out of the province of Massachusetts. Some records say Mary Dyer was subjected to this punishment and other records say she was not. She was

married to a prominent man and was herself well-known. Whichever was the case, after she and her husband were safe in Rhode Island, Mary felt she had to bear witness against the horrid anti-Quaker laws.[21] She returned to Massachusetts several times although the Puritans jailed her and threatened her with execution.

The last time she returned to Boston, she carried her own shroud. She said, "My life not availeth me in comparison to the liberty of the Truth." On June 1, 1660 the Puritans hanged her.

Who wouldn't want to identify with an ancestor like this! There is a published record *(Slocumb, Slocomb, and Slocum)* including Mary Dyer's descendants, and tracing the genealogy down to my grandfather, Samuel Storm. Grandmother Phebe's maiden name was Slocum. As a child growing up I heard many stories about Mary Dyer and absorbed a reverence for her. She was referred to as a Christian martyr, a woman punished for her beliefs, a woman who spoke out to a powerful and punitive government against what she believed was wrong. My mother encouraged

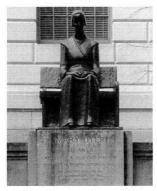

Sculptor: Sylvia Shaw Judson
Photography courtesy of Louise Farrell Studio

me to also be willing to stand alone against the current of my high school's social pressures. During the Civil Rights fights in the 1950's and 60's, Mother stood up against the racism in our town although none of her friends did.

In the 20th century historians began to write about Mary Dyer's life. They believed that her murder by the Puritans influenced "the wonderfully liberal Charter by Charles II to the province of Rhode Island to make it the first spot on earth on the globe, whose religious toleration and absolute freedom of worship was set by law."[22]

That Charter's language can be discerned in our nation's Bill of Rights. Mary Dyer was buried in an unmarked grave on the Boston Common. A statue of her, donated by a descendant, overlooks the commons from its position in front of the Massachusetts State House. Her best friend, Ann Hutchison, stands on the other side of the State House.

Mary Dyer raised her voice, calling upon the most powerful men of her day to strike down a cruel law. Not lady-like. Not deferential to the men. How odious it must have

been to those Puritan judges that it was a woman who cast off the expectations of her sex to rail in public, calling them out on a moral issue. She even defied her devoted husband by returning to Boston when he was away from home and could not stop her or accompany her. She paid with her life for her stiff resistance to the Puritans.

What an inheritance. On the other hand, if we descendants fancy that we inherited some kind of sturdy moral fiber from the martyr Mary Dyer, we certainly have to own an inheritance from a woman who lived much closer in time to our own lives.

So what is to be made of Grandmother Phebe's diagnosis of chronic mania? If there is a strain of mental ill-health running in our family, it has manifested in the last three generations as a proneness to depression. My mother, Phebe's granddaughter, was bed-ridden for months with depression at the onset of menopause, complicated by suppressed anger. And perhaps depression, in a virulent form, was what bedeviled Phebe. On the other hand the word *"delusional"* is mentioned once in her record although I don't know exactly what delusional meant at that time. She may have imagined that

her family was still on a Nebraska farm. She may have claimed that she had a right to send letters to her friends and family. While in the asylum she had no rights.

Phebe Ann Slocum Storm was reported to be afraid to remain alone in her room, and *"thinks no one knows where she is."* Isaac and her children knew where she was, of course, but Phebe may not have known where they were. The absence of letters to and from her leave so much unknown. By the time Phebe was admitted, many of the previous liberal practices of the hospital such as Sunday evening singing, dances and walks into town, were being curtailed at the Lincoln Asylum in the interest of security, that familiar excuse for cracking down. The hospital administrators appear to have begun to think more like prison wardens and though previous administrations had encouraged patients to write letters, that was no longer the policy. Information sent out to family and friends might have spread bad stories about mismanagement or mistreatment of patients. Therefore Phoebe, a literate woman who, like all her kin, had been a steady correspondent, was prevented from writing letters.

The exchange of letters within families in the era before

the widespread use of the telephone, was a constant in life, especially for farmwives who had fewer chances for socializing than women in towns. The instinct a twenty-first century woman has to check her cell phone was for the nineteenth century woman the instinct to check her mailbox. To write to family left behind or family who had picked up and left their relatives was to reassure loved ones, to brag on one's children, to send out news of births, deaths, or illness, and for some to reach beyond isolation.

> *"I have not been well for 2 weeks and Ella [oldest daughter] had to stay at home almost all last week. She did not like it either. She is studying, reading, writing, spelling, drawing, grammer, geography and arithmetic. I will send you some [pictures?] soon as she gets them done.*

The constant preoccupation with the weather, a farmer's friend or worst enemy, filled letters which crisscrossed the country on trains.

> *"We are having some catchy weather here, freezing like sin. Had several little snow storms…The ice on the Missouri is 18 inches thick."*

Reports or inquiries about crops and animals kept friends in touch with a woman's life.

> *"We had more peaches this fall then we knew what to do with and some of the finest ones I ever saw. I dried and made preserves, made eight gallons of peach pickles."…John and Joe and Lassie and Tom are gathering corn. They have about 20 acres gathered. They have about 20 more to gather and fifteen to snap… The prices of grain and hogs are down low, corn 15 cts bushel, he got 75 cts bushel for potatoes by hauling them to Brownville. There was millions and millions [grasshoppers] here in our county but to late to do much damage only to the corn—they eat every blade off the stalk and the corn fields looked just like sugar cane when it is stripped."*

Women needed to communicate how good things were and how bad.

> *"We have considerable sickness in our family, Joe cut his foot this spring and had a terrible time of it, had to keep him under the influence of opium to keep him from taking the lockjaw and that deranged his*

urinary organs and he came near dying and soon as he got better baby and Frank took such a cold it settled in their lungs and they were quite sick but are getting better now."

And they could send fanciful invitations to their mothers. *"Come out and get some fried cakes for I have a great big barrel of lard and lots of sorgum and flour."*

These quotes are not from the letters of random farm-wives. These were all written by Rachel Jackman Storm, the wife of John Storm, Isaac's older brother. These letters were written by Phebe's sister-in-law who lived on a neighboring farm in Nebraska. These lines are taken from Rachel's letters to her mother in the 1870's. During that period, still on the Nebraska farm, Phebe would have been reporting the same news about crops and weather. Rachel, who has seven children and a husband she writes about with adoration, still writes steadily to her mother and longs for letters from her relatives in Indiana.

Tell that sister I think she might rite to me as I like to read her letters so much. I will try and answer them. I know if I had a lovely sister out west I would write to her.

A late entry in Phebe's hospital record says, *"Talks quietly to herself."* Talking to herself might have offered the only kindred spirit she could find. Not allowed pen or paper, Phebe protested. This was one of her few arguments with the staff. But, of course, who would listen to her. She was just a little woman and a mental patient at that.

In the last ten years of her hospitalization, the words *"rational" "contented and helpful" "always quiet"* come up again and again, but Phebe was not legally permitted to discharge herself from the asylum. Not even her doctors could do that. Only her husband could do that because he was the one who committed her. And for some reason, Isaac Storm didn't do it.

I know a lot about the Storm women, my mother's family. These were not folks to dispose lightly of a mother who would have been an inconvenience on the prairie. Mary Lillian, middle daughter was all her life a generous and selfless woman. I knew her as Aunt Minn when I was a little girl. When I played at her house I could count on cookies and total indulgence of any naughtiness. It was well-known in the family that she raised her children this way—gentle, forgiving, and

always shining on them the light of a mother's pride. Once, when she had finished making new clothes for her younger son, Cedric, he, with the confidence and pride of his father, marched downtown to show off his new suit and white shirt. But when he came home, he was riding a horse and wearing only his underwear having made a trade with an Indian who knew fine tailoring when he saw it. Cedric's mother sighed.

I knew Zoe whom I never met, better even than I knew Mary Lillian. The reason for this irony is Zoe was my mother's beloved drama coach. Zoe was also her temporary mother when Virginia's own mother, Bertha, was bed-ridden with heart disease. Aunt Zoe had enormous influence throughout my mother's childhood. Although Zoe ran the Clinton Post Office during the day, her evenings were given over to training her little niece in reciting dramatic "readings" and poetry to audiences. Even when Virginia, a smiling child with large eyes, was so young she sat in a high chair, she would stand up in it to recite at men's clubs which would give her a little trinket afterwards. "She could make the grown men cry," was a common report on little Virginia's dramatic power. Zoe would keep a book of poetry or dramatic readings by her window at

the post office, so that when she didn't have a customer, she could search for pieces appropriate for her niece to deliver. Besides the Carleton book I have Zoe's copy of *Green Fields and Running Brooks* by James Whitcomb Riley. These humorous and often sentimental poems were the stuff of the nineteenth century performance "readings."

When Virginia was a little older, and it came time for county or state speech contests, it was Davy, Zoe's husband, who bought the girl new shoes. Zoe would buy the fabric and Virginia's mother would make a new dress. "When I arrived at Contest," my mother would tell me with a grin, "I looked like a rich girl." This sharing of the costs was an example of the Storm family cooperating to lift up a child at important moments in her life.

Samuel and Bertha's older daughter, Mary Louise, was a gifted pianist who went to the University when she was sixteen. Their youngest child, Samuel James, Jr. was whip smart and grew up to work with computers at IBM. For people as poor as Sam and Bertha, they ran a very cultured home with Sam reading poetry, Mary Louise playing the piano, and Virginia playing the violin and dreaming of a life on the stage

while Bertha painted china as fast as she could. Aunt Zoe, childless herself, poured out her love to her brother's children. You saw her, the one on the right in the family picture taken on the porch of the house in Clinton.

As mentioned above, in the three generations—my mother, me and my siblings and cousins, and our children—I can see characteristics we inherited from those dugout dwellers. We have deep and loving family feelings, but I see in some of us also an over-weening sense of responsibility. I watched my mother, Samuel's daughter, apologize to her husband for acts she did not commit like bad weather or the traffic—"I am so sorry all this rain is making you late." If there was anything that should be done about a situation, and even if there was nothing that could be done, we were the sort who would search our consciences for days asking, Wasn't there something I could have done? An exaggerated conscientiousness was part of our heritage from the Storms. If we had a family crest, its Latin motto would have been *mea culpa*.

Back in Nebraska while Phebe was still at home, her anxiety must have been worsened by fear of the loss of their farm. And her anxiety and weeping must have dampened the family's spirits as they tried to stay brave through the years of drought and the dwindling price they could get for their crop. Phebe's daughters would have had the care of their mother when she was home. They would have been the ones to try to make the depressed person happy and to reassure the quaking woman that she was safe from whatever she feared. But if their mother was clinically depressed, they couldn't help her. Their demonstrations of love and affection could not penetrate a brain chemically unbalanced. These Methodists didn't believe in drink, but they must have tried medicinal spoonsful of whatever they could come by to quiet their mother. Perhaps Phebe was in a state that convinced Isaac he had no choice but to leave her behind. And more than anyone else her daughters knew how little they could do for her.

Did they do the right thing in letting their father take their mother to the asylum? I believe, at least, they knew there was no choice once their father had decided. In that section I mentioned earlier of *One Hundred Years Of Marriage*, the mother of the family did go with her husband and son onto the Oklahoma Territory claim. This woman watched the two dig into the earth to make a shelter. Her son, the narrator, told that she

didn't spend one night in the dugout, but waited for her husband to fall asleep then left to sleep in the wagon. But one night that woman climbed out of the dugout, put on her black silk Sunday dress and tried to hang herself from the only tree on their claim.

Phebe talked about suicide the day she was admitted. And why not? How else could she escape depression and anxiety in an era with no Zoloft, no Prozac, no Elavil, no psychotherapy, no understanding at all by the doctors of her problems?

When they got on that train headed south for Oklahoma Territory, Ida, Mary Lillian and Zoe knew that they were leaving their mother, perhaps forever. What were their thoughts as they lay on pallets in the pitch-black darkness of the dugout? What questions haunted them? What were the images in their heads of the asylum? One could imagine that thoughts of Phebe filled the airless night in the dugout.

It is important to see the Asylum in Lincoln. It's a beautiful building—not the Gothic monstrosity I was expecting.It looks like a grand, resort hotel, right? A place where ladies

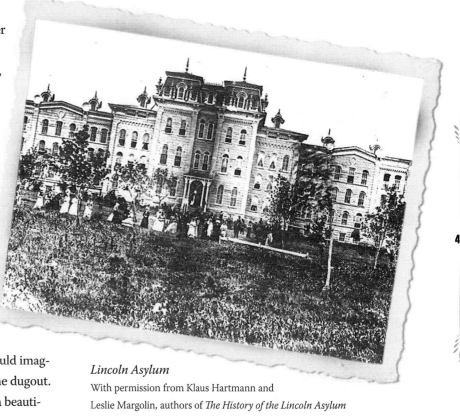

Lincoln Asylum
With permission from Klaus Hartmann and
Leslie Margolin, authors of *The History of the Lincoln Asylum*

43

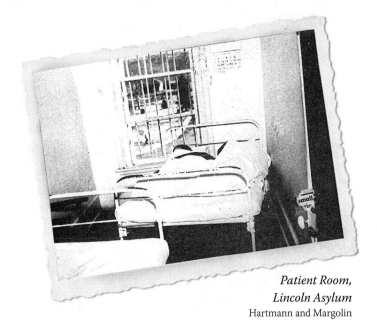

Patient Room,
Lincoln Asylum
Hartmann and Margolin

carrying parasols and gentlemen in top hats might stroll the grounds of a Sunday afternoon. This is the posh-looking place where Isaac left Phebe the last time he saw her. It does not appear to be suffering from drought. No one is going to foreclose on this grand institution. Records show that the state of Nebraska funded it with off and on generosity. One can understand Isaac's believing that he left his wife in a safe and comfort-

able place. He had brought familiar things to furnish her room, a carpet, lace curtains and her little armless rocking chair.

But this little room with two beds and with two sleeping patients in each bed is the view from inside the asylum. Isaac probably didn't get a tour of the facility before he signed the commitment forms. There was no reason for this state institution to court prospective families with tours. This picture of a patients' room is an eerie nightmare. I don't fault a mental institution for the bars on the window. It is the tiny room and the two patients to a bed that seems really intolerable to me. Where was the privacy to collect one's scattered self? How was one to get any healing rest sharing an iron cot with another mental patient who could be weeping with loneliness or shouting with rage. Perhaps Phoebe had a private room or a private bed or at least a dose of whiskey at bedtime.

A calendar is visible hanging on the wall, the only decoration. Maybe it was the policy of the hospital to keep the patients aware of the passage of time, but it just reminds me of the marks on a prison wall to count down the days of an inmate's sentence. There was a large, sparsely furnished common room a patient could go to during the day. There was

the lawn outside where they could walk. So the façade shown above forgives Isaac for abandoning his wife there, but the lengthy abandonment forgives Phebe for crying to go home.

Did Isaac tell the asylum director that the family was considering leaving Nebraska for good, that the place Phebe was crying to return would be scraped clean of all its animals and equipment and abandoned by its family? Whatever relief the children and their father felt by not having the care of Phebe, guilt, shame and grief must have accompanied them into that dugout.

The harshest part of this story for me is that Phebe was left in the hospital long after her hormonic storms were over, and she was just a quiet, well-behaved old lady. According to the records she was "paroled" in 1913. I was aghast when I read that, shocked that she'd been there so long—fifteen years after her last admission. What happened in 1913 that she was finally able to get out? Did they need the bed? Was she pronounced cured? Was she pronounced hopeless?

I asked my mother about this. Mother had been born in 1913 and grew up knowing Phebe only as her beloved Grandmother. My mother was not eager to answer. She must have known that her answer would only deepen the mysteries for me, but she told me 1913 was the year her grandfather, Phebe's husband, Isaac Storm, died. It took five months for Mary Lillian to complete all the required paper work to get Phebe released. Mary Lillian went to Lincoln and brought her mother back on the train to live with her and Albert in their large, tree-shaded bungalow in Clinton, Oklahoma.

Isaac, Phebe's husband, had been the head of the family. At this time any husband could have his wife committed if he claimed she was insane. It seemed fairly clear that Phebe couldn't come back into the family until her husband died. The wondrous thing is that Mary Lillian's desire to free her mother lasted all those years in the face of her father's refusal. The mystery lay in Isaac's motives for leaving her in the asylum after she might have been able to rejoin the family. Was he in touch with her doctors? Were memories of her derangement so great that he never wanted to see her again? Did he believe that her care would put too great a strain on his daughters?

Three newspapers wrote obituaries for Isaac Storm. His bravery in the Civil War and accomplishments as a civic leader were detailed. One obituary writer closed his piece with the words "May the hereafter contain a greater measure of

happiness than was in this life." This last line seemed unusual to me. It was a public acknowledgement of the man's permanent sad demeanor, apparent even to this anonymous obituary writer. As we know, Isaac's losses had been major. Besides the sorrows of losing two brothers, Isaac also lost his daughter Ida whom he had set up so generously in marriage. Ida died of typhoid in September 1911. Two days later her older daughter Phebe, the child she was carrying when she and John pioneered into Oklahoma Territory, died at age twelve, also of typhoid. One month later their younger daughter, aged five, died of typhoid. Losing your first-born child and two granddaughters within a month speaks of incredible pain for Isaac as well as for the whole family, especially his son-in-law John and the surviving Coatney children.

Another obituary revealed that Isaac's wife had "been a patient in a Nebraska hospital for many years," so Phebe's incarceration was not a secret. Isaac certainly came by his sad appearance honestly. But why wouldn't he relieve whatever grief or guilt he suffered regarding Phebe by returning to Nebraska to visit her to see if she could come back with him to Oklahoma?

Isaac died suddenly, falling over with apoplexy, a ruptured or blocked artery in the brain, at the dinner table in the home where he lived with Albert and Mary Lillian Randol.

Perhaps on that train ride back to the state of Oklahoma Mary Lillian reported to her mother what had happened in the family while Phebe was away for fifteen years. Like the opening of a time capsule, so much family news would have burst upon that small woman who may have already been staggering with her first breaths of the outside world. There was a lot for the daughter to tell her mother besides the sudden death of Isaac about which mother and daughter must have felt a powerful ambivalence. There was the family's life in the dugout, the sod house, and the frame house in Clinton. Mary Lillian's husband Albert had a new partner in real estate. Samuel had made a good marriage to the sweet and forgiving Bertha. There were three Randol and Coatney grandchildren Phebe had never met. So much news! Phebe's heart must have been pounding. Coming out of the tight and regimented world of the asylum into a world that had swept along without her, may have felt like a mixed blessing, especially when Phebe learned the darkest news—the long, feverish and painful suffering of her daughter Ida and her two little girls.

Once Phebe was living in Mary Lillian's home, she rose very early in the mornings to polish the nickel plate under the stove in her daughter's kitchen. Then she sat in her little rocker by the front window to sew and mend. She was famously quiet and busy. A woman of Quaker heritage, she had not given up using the words thee, thou and thy of Quaker speech. Still quite lady-like, she spoke ill of no one, and returned the love that surrounded her. Phoebe died on Christmas day, 1925, at the age of eighty-three.

During all those years in the asylum, Phebe Ann Slocum Storm had no way out. Like the pioneer women for whom there was no going back home once their husbands had insisted on the perilous journey, Phebe was powerless. As a married woman, she had no rights. She was thrown back on her powers of endurance and her habits of obedience.

Have the women of our family made any progress? I believe so. A recent photo of our youngest granddaughter shows her, age eight, standing very straight, poised and proud, playing her violin on stage at school. Our older granddaughter, 15, also a musician was caught by a newspaper photographer as she marched at the head of a New York protest parade, flanked by armed police and motorcycle troops. She holds above her head a poster she made that reads "We Are Not Afraid." Seeing that picture makes my chest swell and tears quicken. More than artists and activists, these are whole, unafraid girls though they emerged out of generations of women who were silenced. As for myself, I taught courage to my daughter, but I did not always model it. I had one foot stuck in the behaviors of a past generation. However, discovering what I could about Ida, Mary Lillian, Zoe and their mother Phebe, has made me bolder and set my other foot firmly in the twenty-first century.

Did I get to know Phebe Storm in this brief focus on her? Of course not. She seems more of a mystery to me now that I have uncovered more facts of her life. What I do know is that a woman abandoned in an asylum might have spent years rehearsing her grievances, boiling them down to a bitter rant. She could have lashed out at the daughter who came so late to free her. She might have spent the rest of her life telling the world her wretched story.

But that was not the person who emerged after fifteen years in the Lincoln Asylum. Phebe had not closed her heart. If her experience in anyway changed her it was to make her even more sensitive to other people who were weak or different or criti-

cized, or those who couldn't speak for themselves. "The grocer's little girl may be backward, as you say, but her smile is so sincere."

Phebe's son Samuel left a glimpse of his mother in his own memoir, framed by a fantasized trip to Nebraska to show Bertha his boyhood home on the abandoned farm:

> *Of course while at the farm I was reminded of Mother, that wonderful mother. Never once did I ever hear her say anything detrimental of anyone. Never have I been able to understand why one so good and pure, should be afflicted and taken from us. But how wonderful it was to have her returned to us in good health. I wonder if we really appreciated our mother as we should.*

All that is left of Phebe's physical possessions is that little armless rocking chair, the one Isaac took with her to the asylum the last time in 1898. It has come down in the family, and still exists. It is sturdy with heavy oak grain and dark gold color. Each time I see it, I am moved by thoughts of her, cut off from her family, a woman who had no power to free herself, a woman leading an imprisoned and muffled life, someone my size, rocking, quiet and obedient, waiting to go home.

The Woman Without a Voice

ENDNOTES

1. Frederick Jackson Turner, "The significance of the Frontier in American History," an essay delivered to a meeting of historians in Chicago, 1893.

2. *Omaha Daily Bee* Newspaper, (January 19, 1893.) p. 2.

3. The Five Civilized Tribes refers to five Native American Nations, the Choctaw, Cherokee, Seminole, Creek (Muscogee) and Chickasaw, who, since the colonial and early federal periods were considered by white settlers to be civilized due to their likeness to Europeans in their practice of Christianity, their centralized governments, literacy education, participation in trade, written constitutions, intermarriage with whites and ownership of slaves.

4. *Omaha Daily Bee*, Ibid., (February 2, 1890. 1.

5. Paul D. Travis and Jeffrey B. Robb, "Wheat," *Encyclopedia of Oklahoma History and Culture*, (Oklahoma Historical Society, 2009,) 1.

6. Lillian Schlissel, *Women's Diaries of the Westward Journey*, (New York: Shocken Books, 1982,) 28.

7. Ibid, 28.

8. Ibid., 30.

9. Ibid., 31.

10. Ibid., 35.

11. Carlos A Schwantes, *Coxey's Army, An American Odyssey*, (Lincoln: University of Nebraska Press,1985), 218.

12. *County Herald* Newspaper, (Dakota City Nebraska, November 13, 1919) 6.

13. *Women Who Pioneered Oklahoma, Stories From The WPA Narratives*, edited by Terri M. Baker and Connie Oliver Henshaw, (Norman: University of Oklahoma Press, 2007) 50.

14. Linda Peavy and Ursula Smith, *Pioneer Women, The Lives of Women on the Frontier*, (Norman: University of Oklahoma Press, 1996) 31.

15. Linda Williams Reese, *Women of Oklahoma 1890-1920*, (Norman and London: University of Oklahoma Press, 1997) 11.

16. Schlissel, *Diaries*, 60.

17. Ibid., 104.

18. Travis and Robb, "Wheat," 1.

19. Klaus Hartmann and Les Margolin, "The Nebraska Asylum for the Insane—1870-1886," excerpted for Nebraska History, (Lincoln: Nebraska Historical Society Press, 1982) 172.

20. Ibid., 174.

21. Ruth Plimpton, *Mary Dyer, Biography of a Rebel Quaker*, (Boston: Branden Publishing Company, 1994) 204.

22. Ibid., 217.

BIBLIOGRAPHY

Baker, Terri and Henshaw, Connie Oliver, editors, *Women Who Pioneered Oklahoma, Stories From the WPA Narratives*. Norman: University of Oklahoma Press, 1996.

County Herald Newspaper, Dakota City, Nebraska, November 13, 1919.

Crawford, Deborah, *Four Women in a Violent Time*, New York: Crown, 1970.

Hartmann, Klaus and Margolin, Les, "The Nebraska Asylum for the Insane 1870 to 1886." Excerpted for *Nebraska History*. Lincoln: Nebraska Historical Society Press, 1982.

Luchetti, Cathy and Olwell, Carol, *Women of the West*, New York: Orion Books.

Omaha Daily Bee, January 19, 1893.

Peavy, Linda and Smith, Ursula, Pioneer Women, *The Lives of Women on the Frontier*. Norman: University of Oklahoma Press, 1998.

Plimpton, Ruth, Mary Dyer, *Biography of a Rebel Quaker*. Boston: Branden Publishing Company, 1994.

Reese, Linda Williams, *Women of Oklahoma 1890-1920*. Norman and London: University of Oklahoma Press, 1997.

Schlissel, Lillian, *Women's Diaries of the Westward Journey*. New York: Shocken Books, 1982.

Schwantes, Carlos, *Coxey's Army, An American Odyssey*. Lincoln: University of Nebraska Press, 1985.

Travis, Paul D. and Robb, Jeffrey B. "Wheat," *Encyclopedia of Oklahoma History and Culture*, Oklahoma City: Oklahoma Historical Society, 2009.

Turner, Frederick Jackson, "The Significance of the Frontier in American History." Essay delivered to a meeting of historians in Chicago, 1893.